EASY DRAWING

PAULO DANTAS

2019

Copyright © 2019 Paulo Dantas

All rights reserved.

ISBN: 9781096344285

CONTENTS

- INTRODUCTION..04
- CAT..06
- HUMMINGBIRD...07
- DUCK...08
- DRAGON-FLY..09
- SHEEP..10
- TURTLE...11
- FROG..12
- PIG..13
- BIRD...14
- PARROT..15
- MOUSE..16
- OWL...17
- FISH...18
- BUTTERFLY..19
- TOUCAN..20
- DHELPHIN..21
- BUNNY...22
- DOG...23
- SWAN...24
- SEAHORSE..25
- BEE..26
- CHICKEN...27
- ANT..28
- WHALE..29
- HORSE...30

INTRODUCTION

Have you ever sketched in your life? If you think only a little, you will soon remember ... Let's think about childhood then, maybe you have drawn on the walls of your house, in various activities at school or even made some drawings of friends for fun. This became natural at that time, when he looked at the world in a different way, picking up other details without worrying about other matters.

This work consists of twenty-five drawings of animals on which are explained, step by step, in detail. Such designs were designed to promote creativity and playfulness, presenting low level of difficulty in its accomplishment. It is worth emphasizing that you will rekindle your artistic side a bit, you may, with some conviction, perfect your memory, while remembering things more quickly and skillfully, as well as improving your concentration, observing details of the objects and, from this perspective , you will see your progress from day to day, and you will notice that it will become sharper with time.

Also, when you draw, you will also amplify your creativity, and you can gradually become a more perceptive person, even being able to face more clearly the facts of your daily life. We might cite some creative people who have achieved satisfactions in life by perfecting their abilities, however, we will leave it to their discretion to remember those people who possess a high degree of creativity.

In this way, you will be developing your right side of the brain, scientifically proven to be the side that commands our creativity as well as its artistic side. We pose this question as one of the most valuable that we mention here in this work.

So get inspired, free up your creativity and draw without fear of discovering some hidden talent or simply draw for pure pleasure.

Paulo Dantas

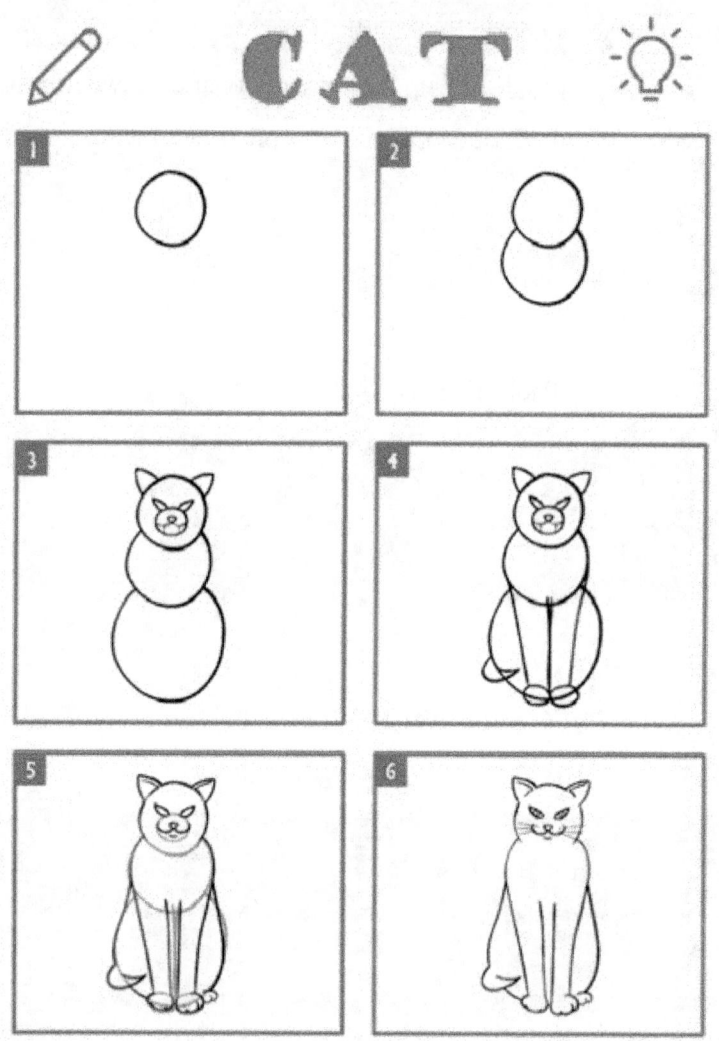

 # HUMMINGBIRD

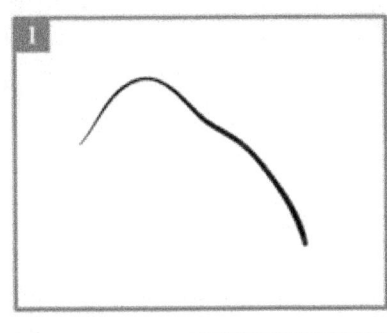
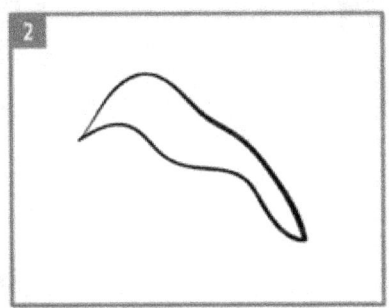
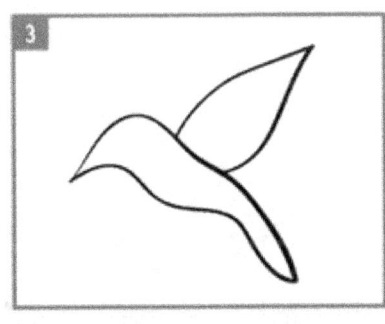
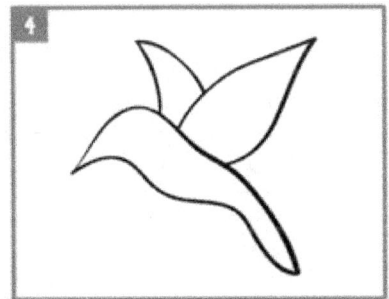
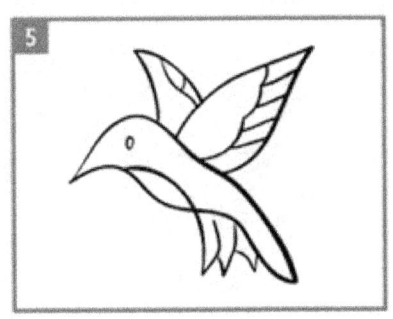
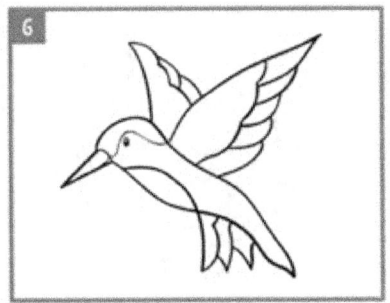

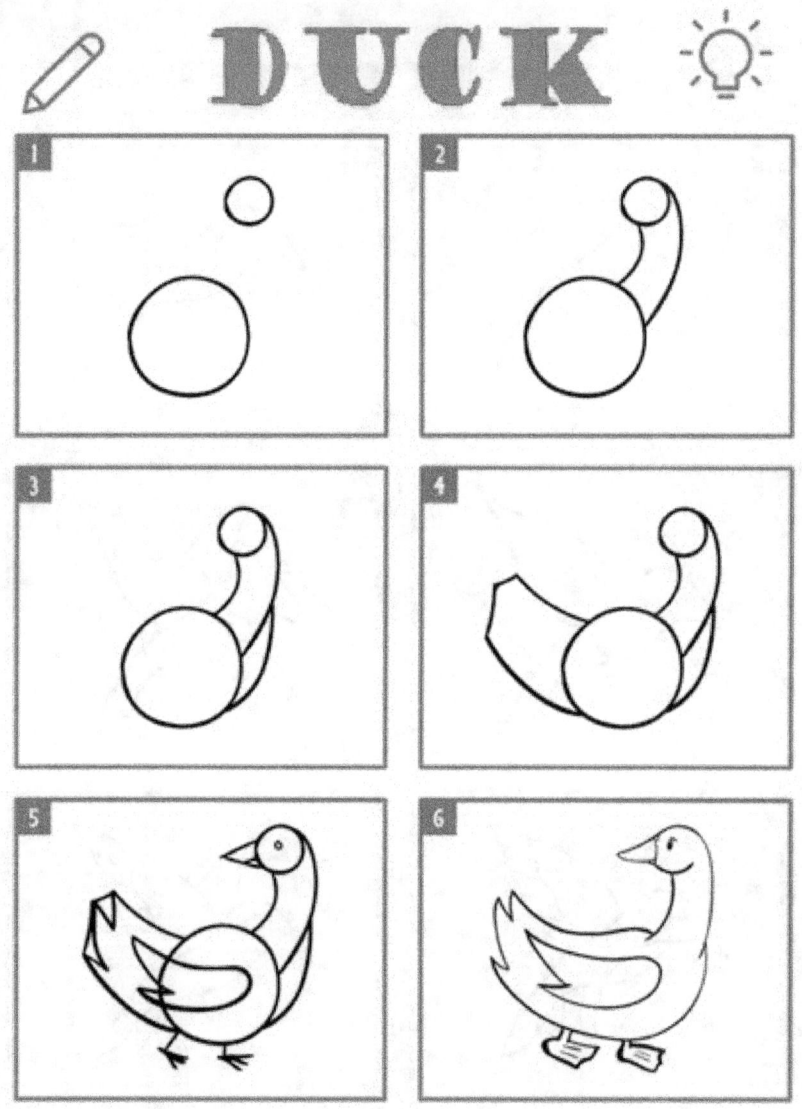

DRAGON-FLY

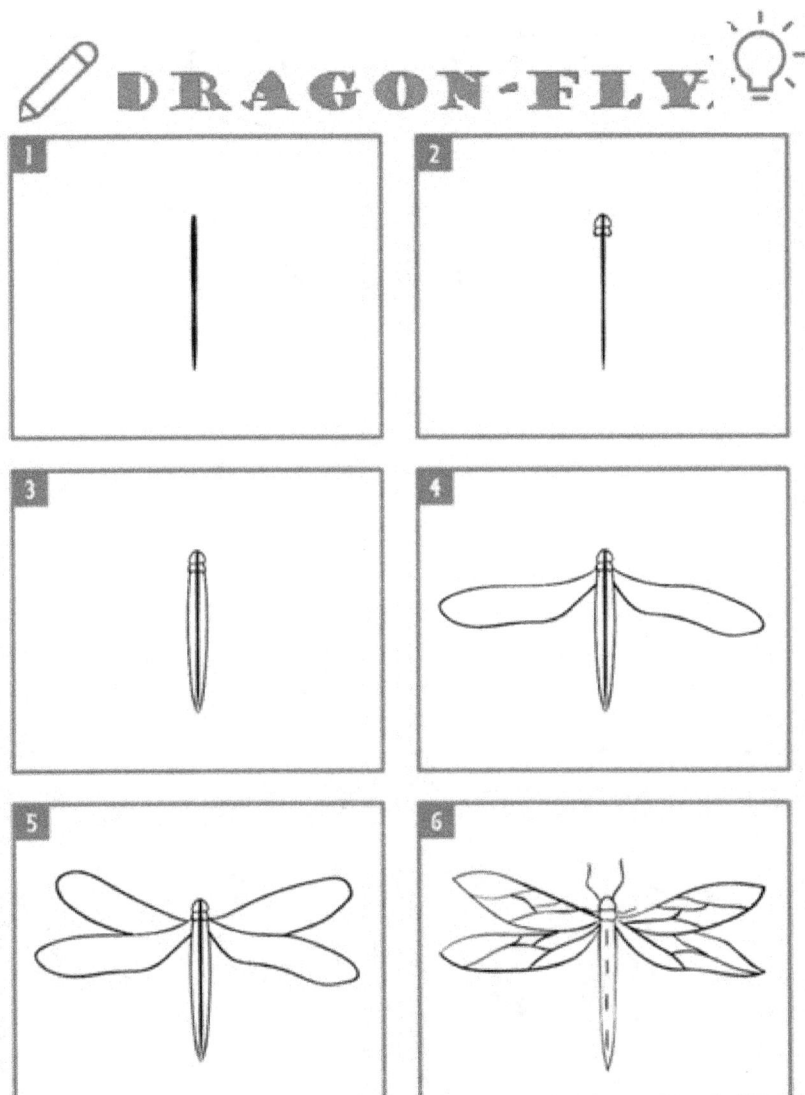

SHEEP

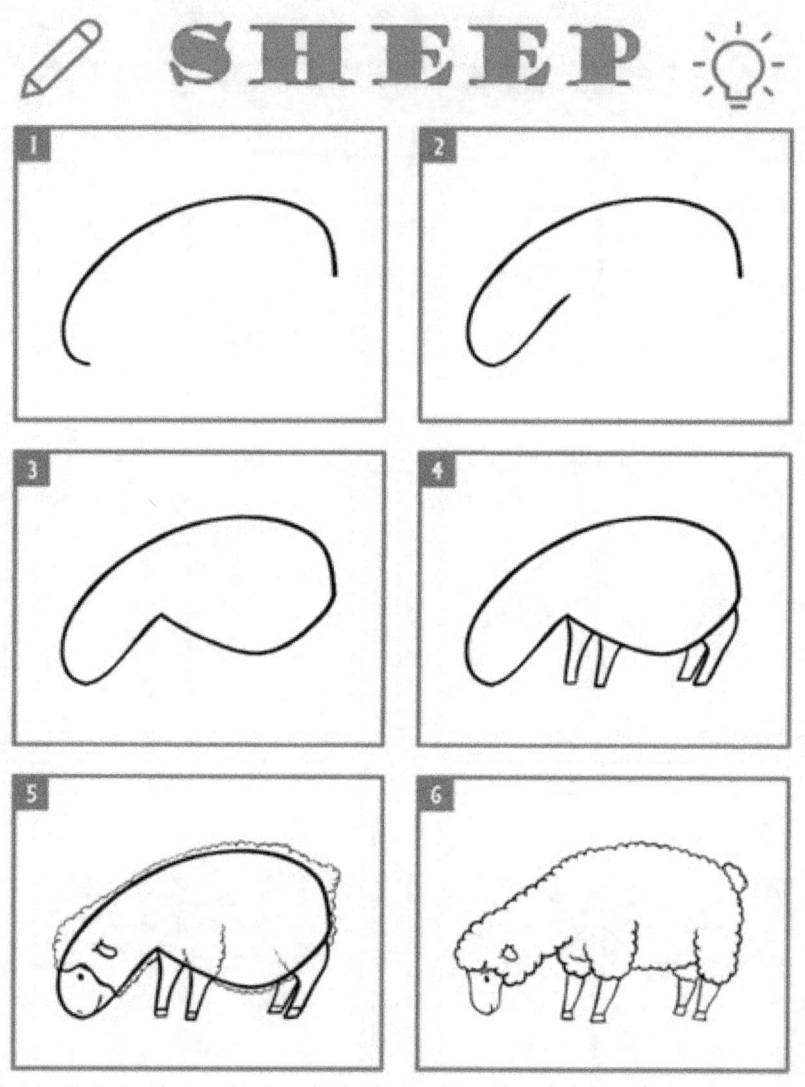

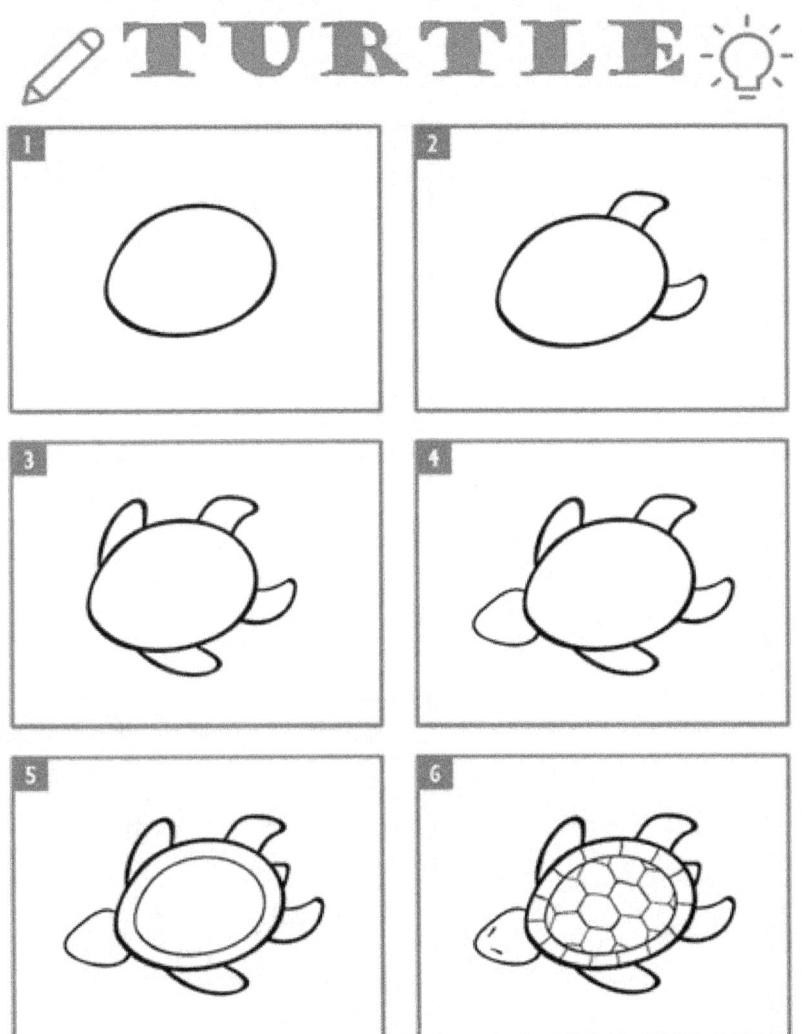

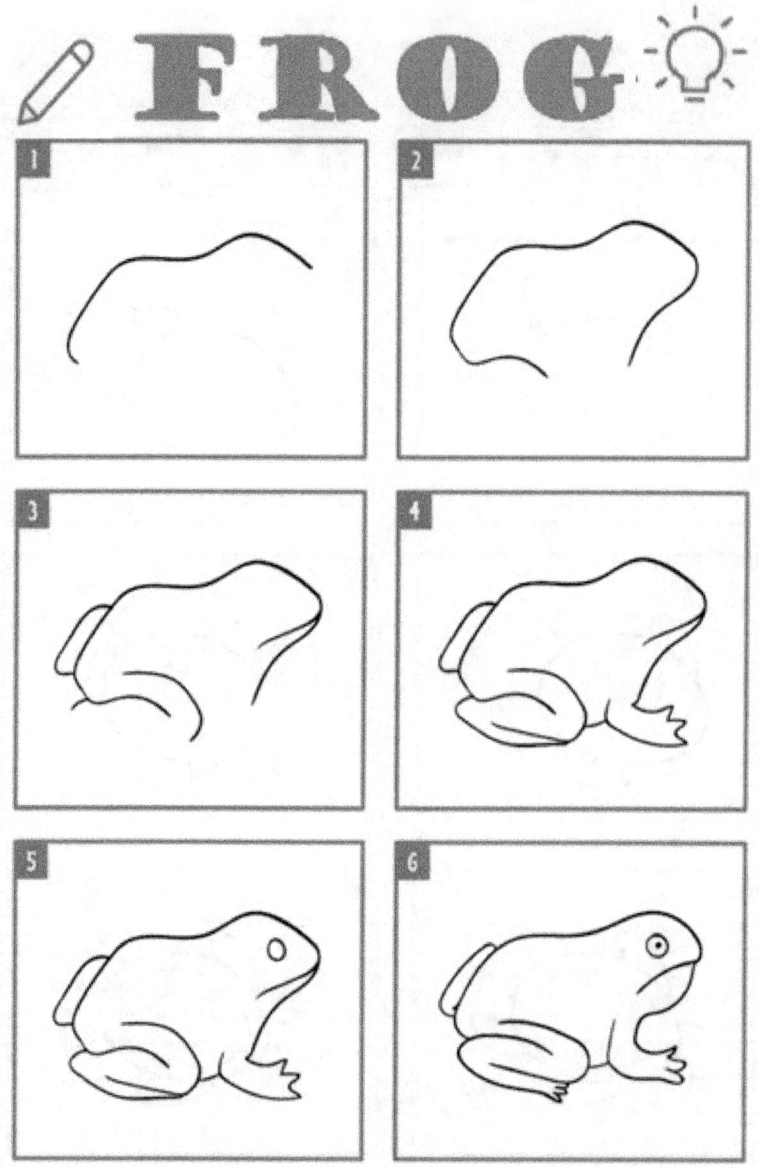

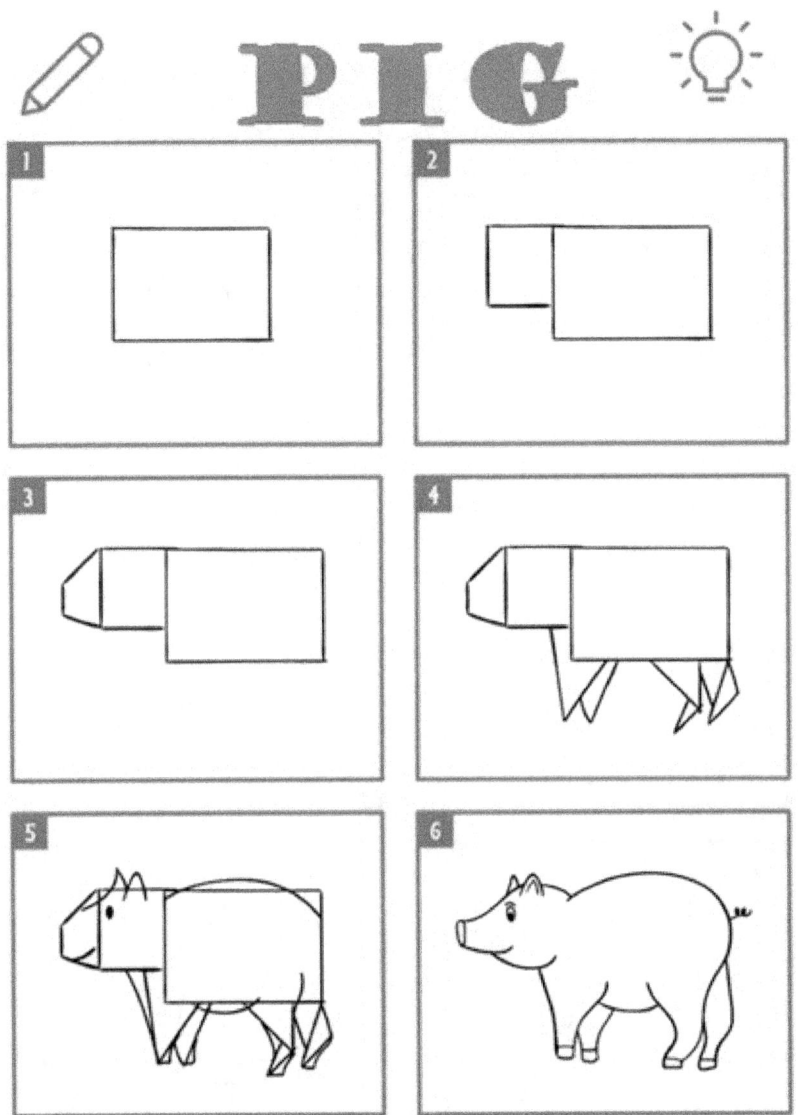

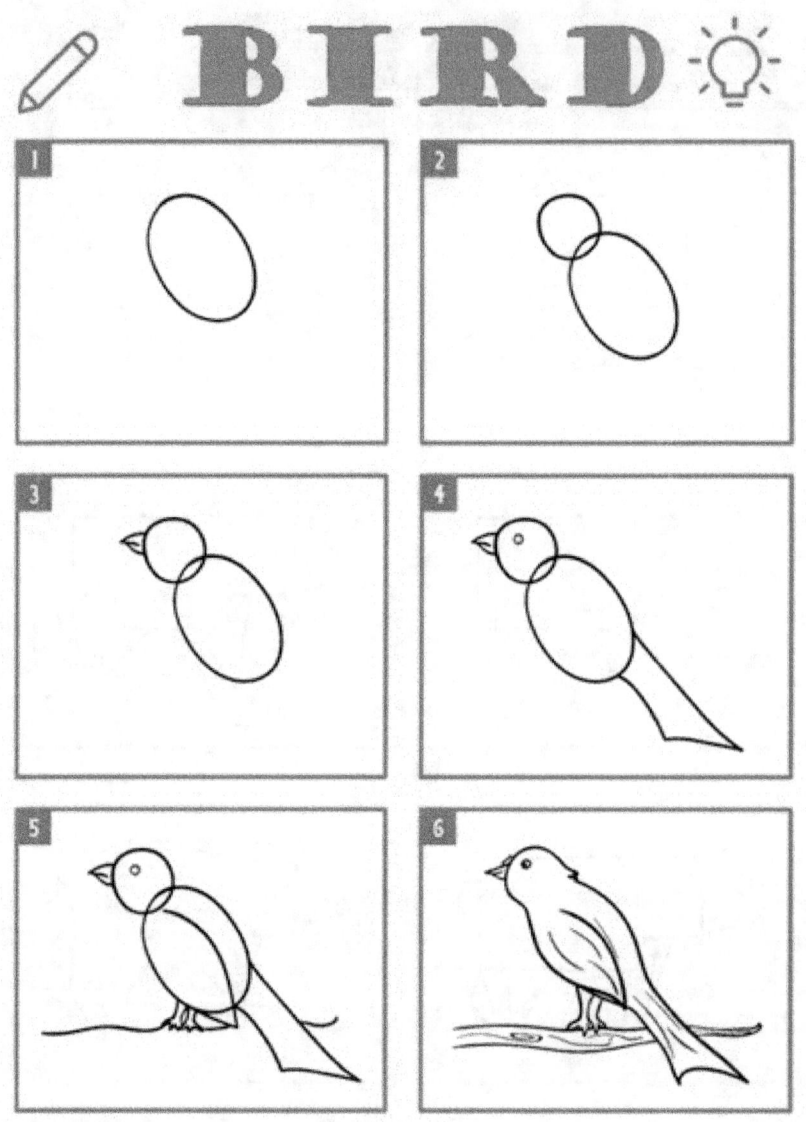

PARROT

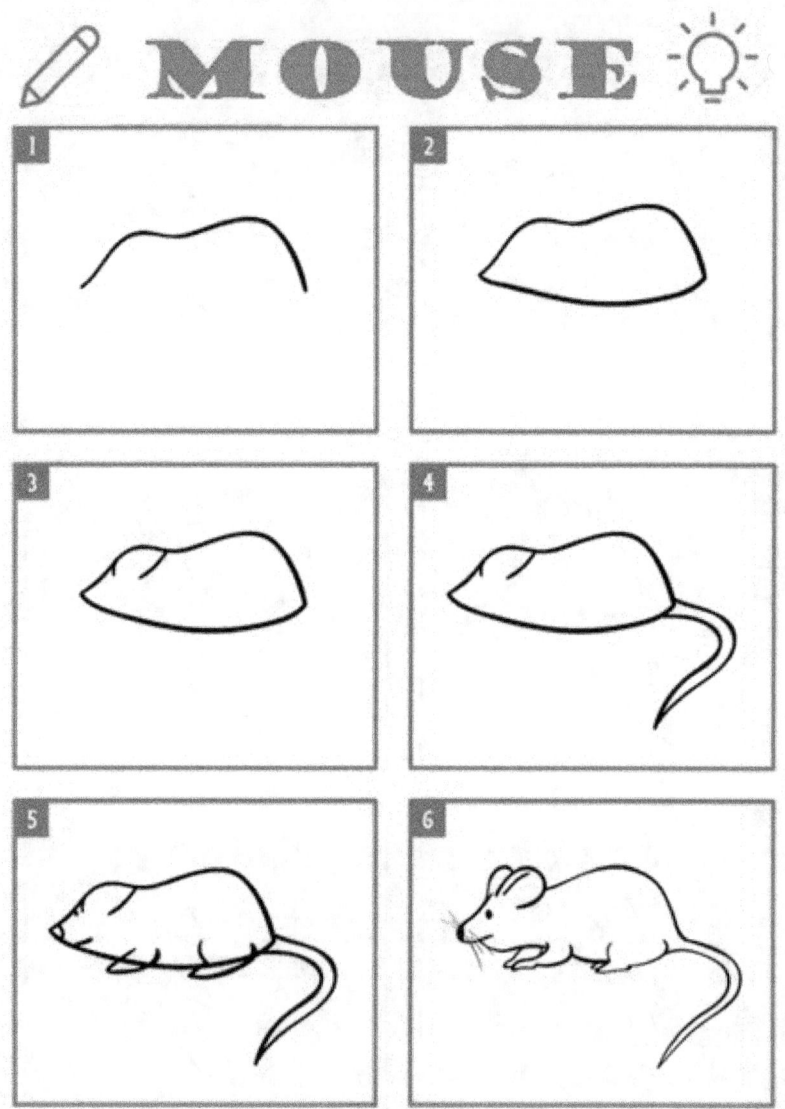

OWL

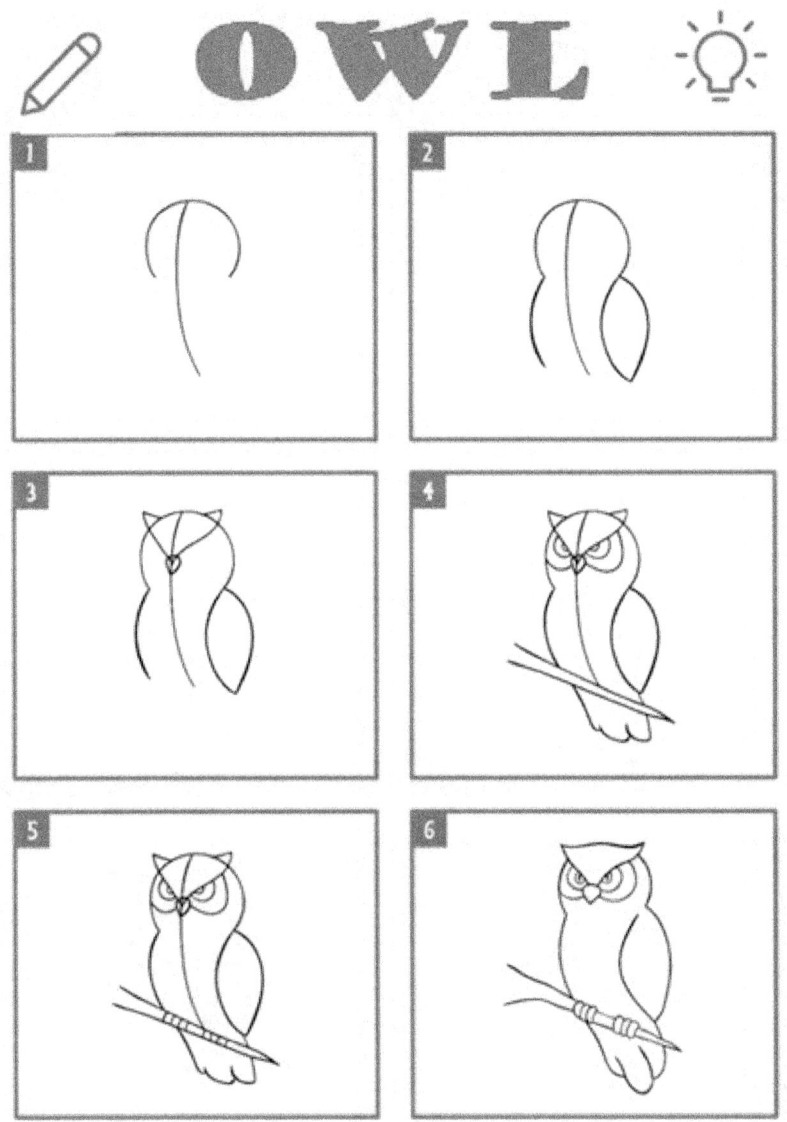

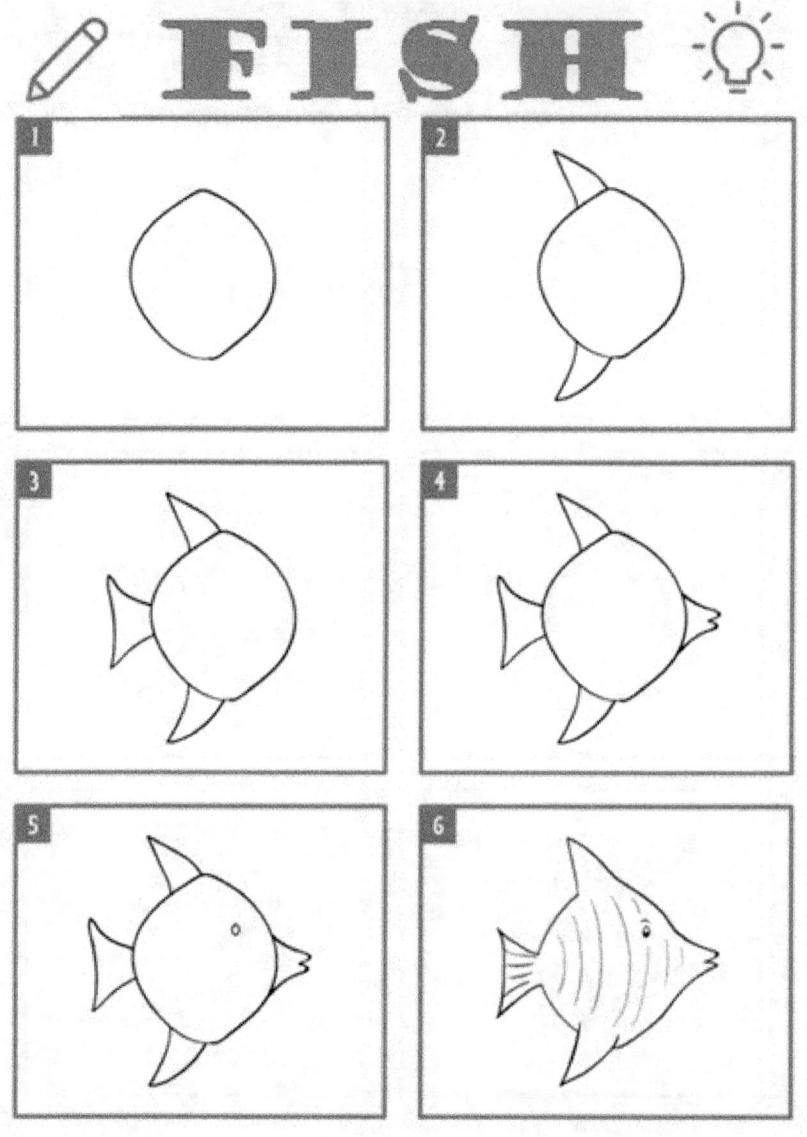

BUTTERFLY

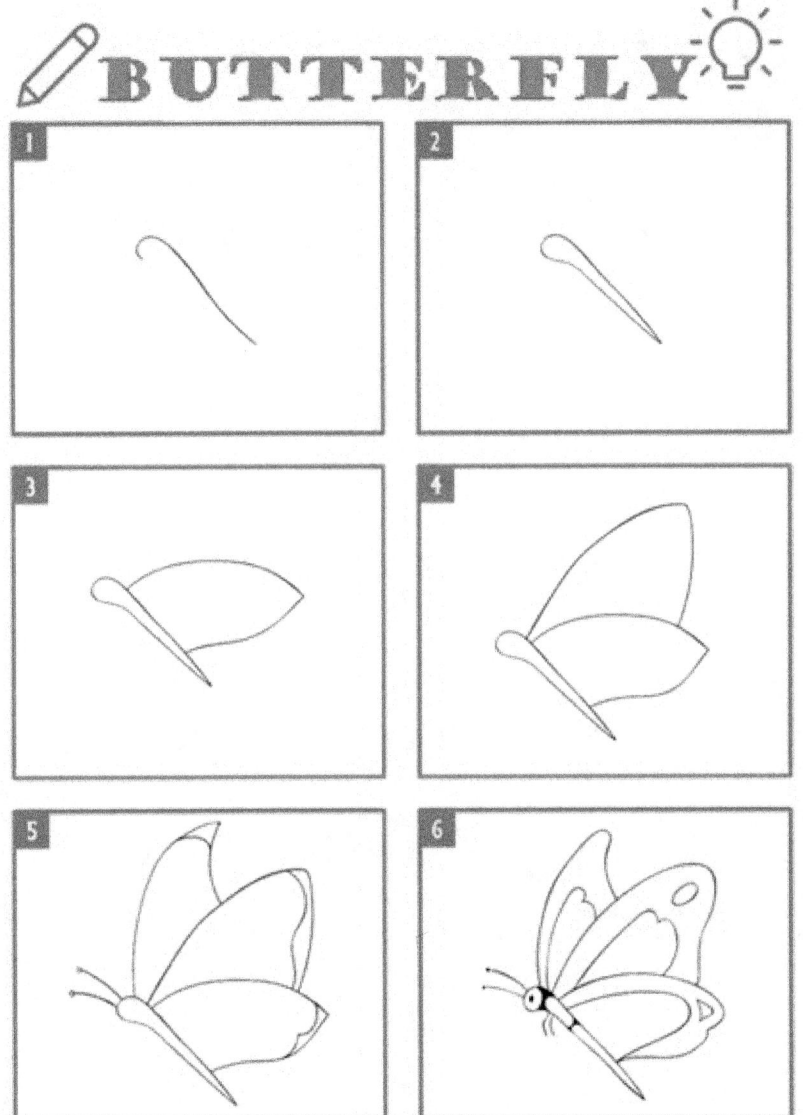

TOUCAN

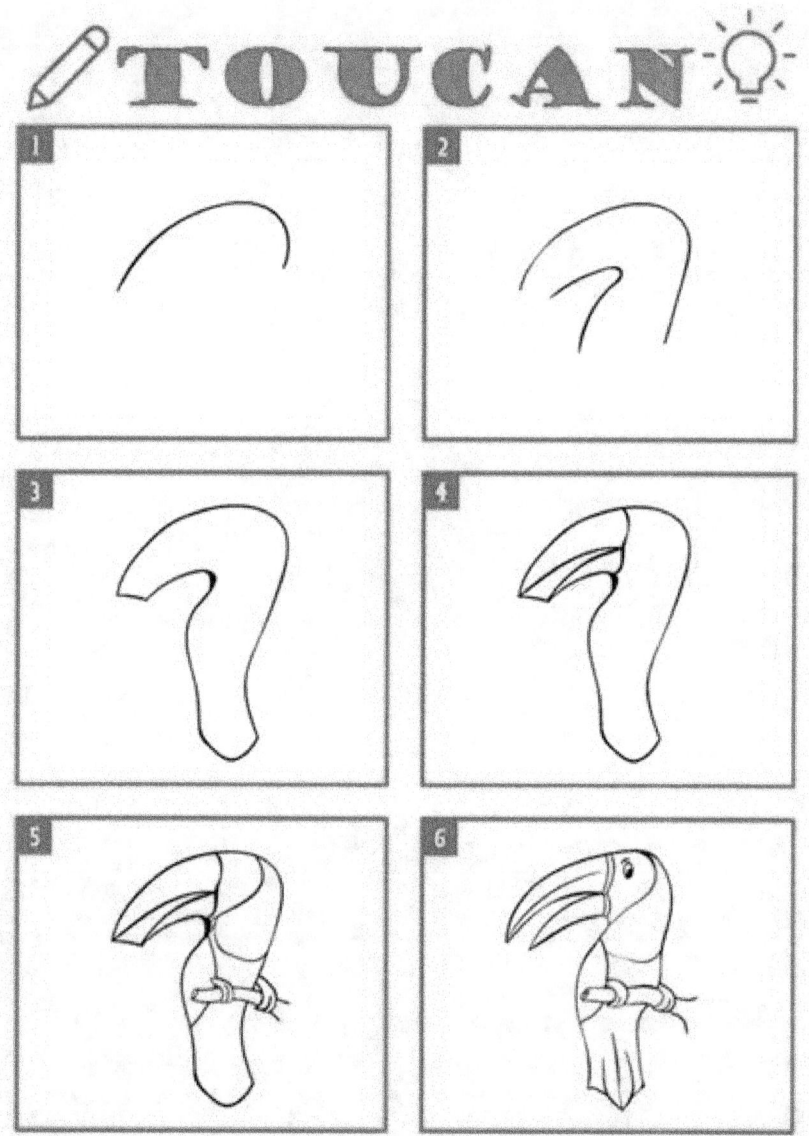

DOLPHIN

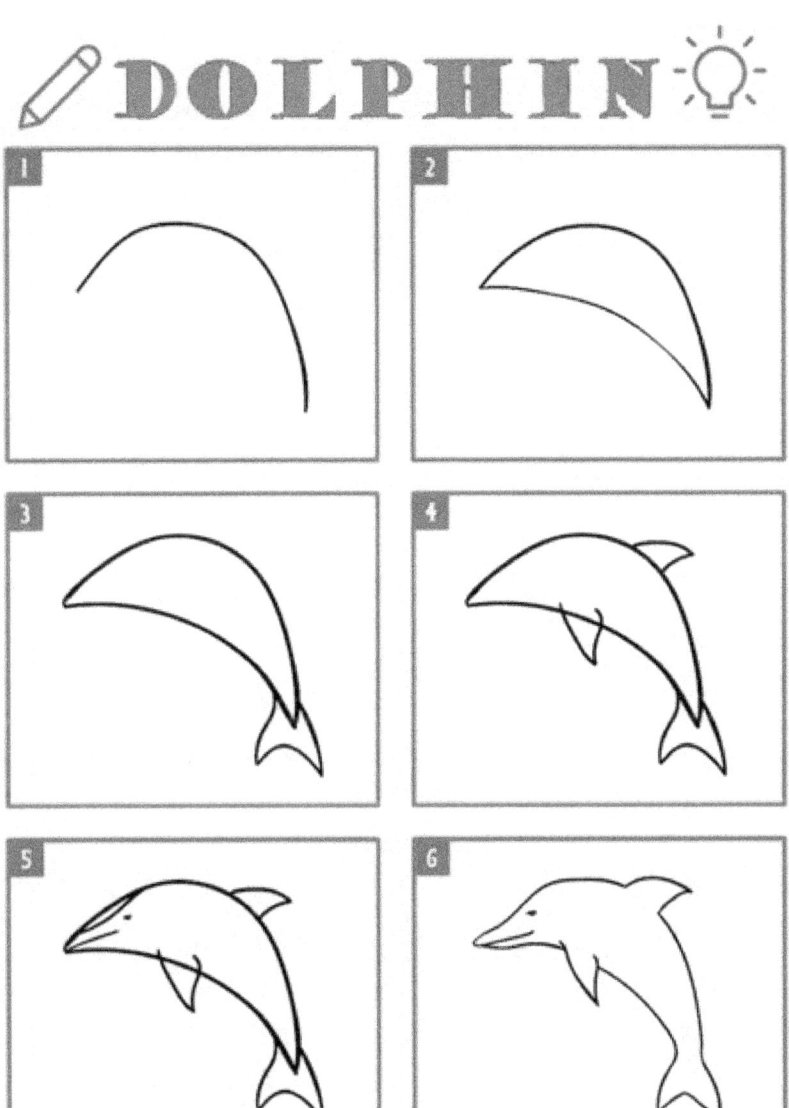

BUNNY

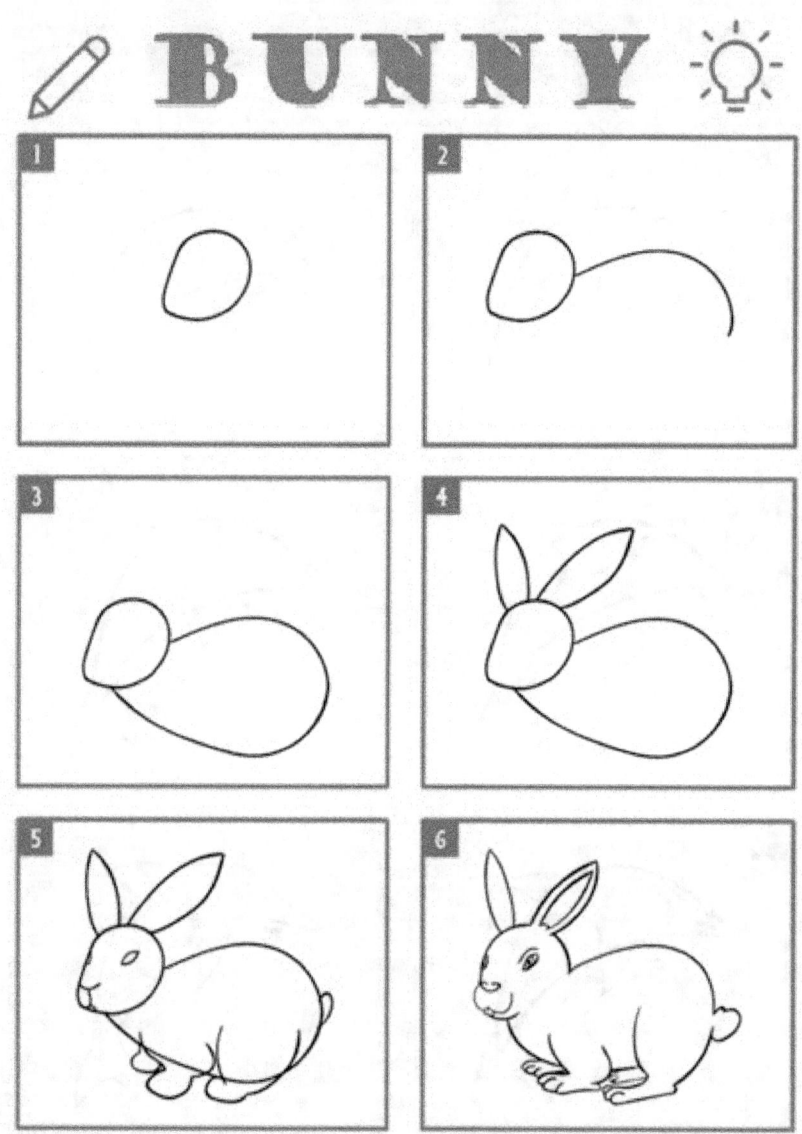

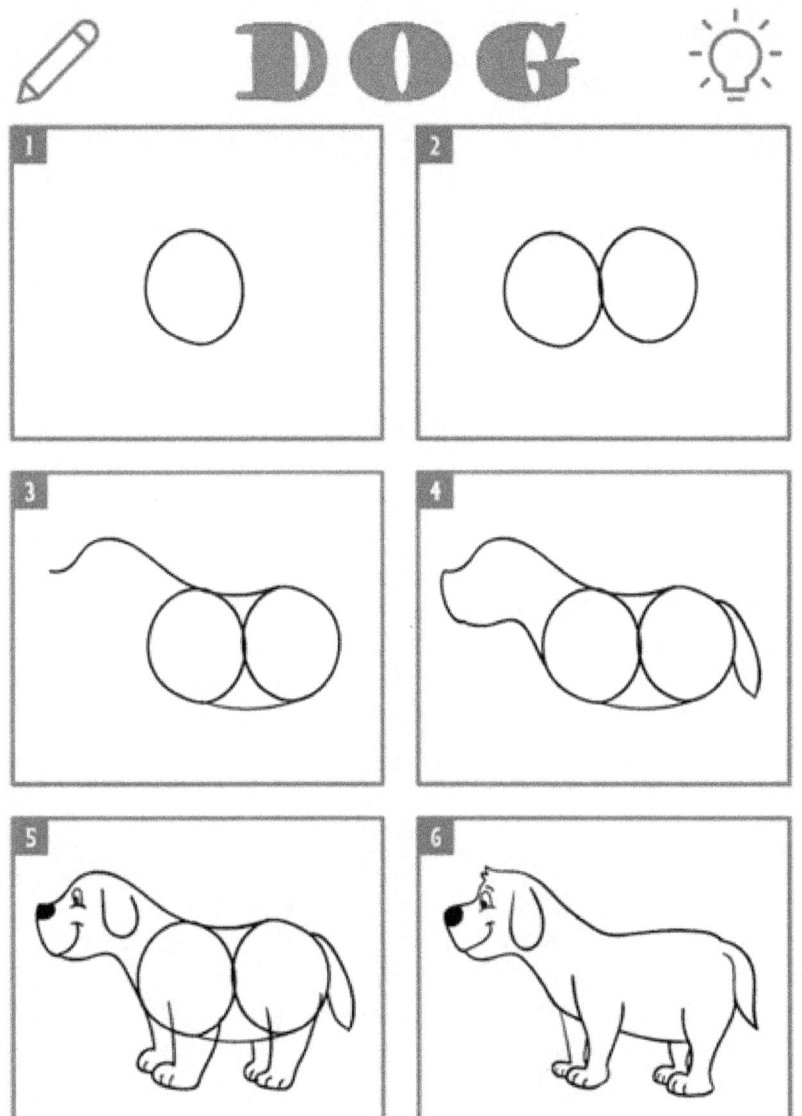

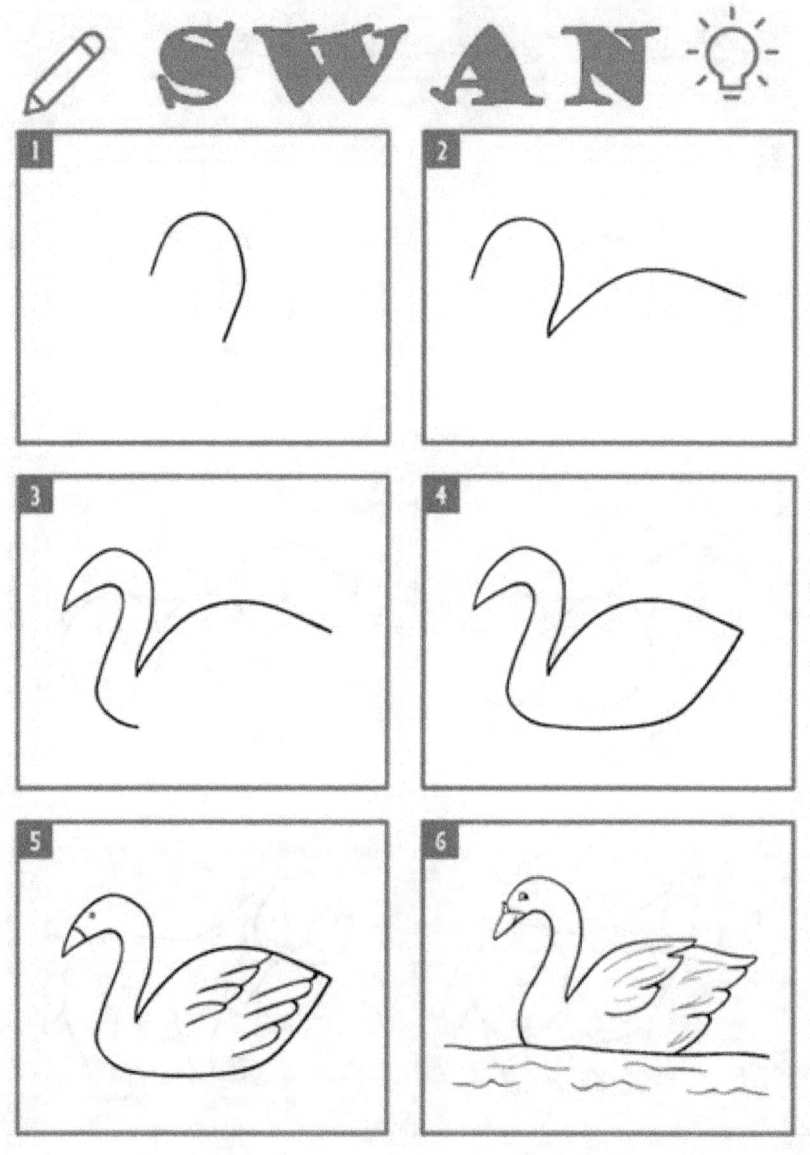

SEAHORSE

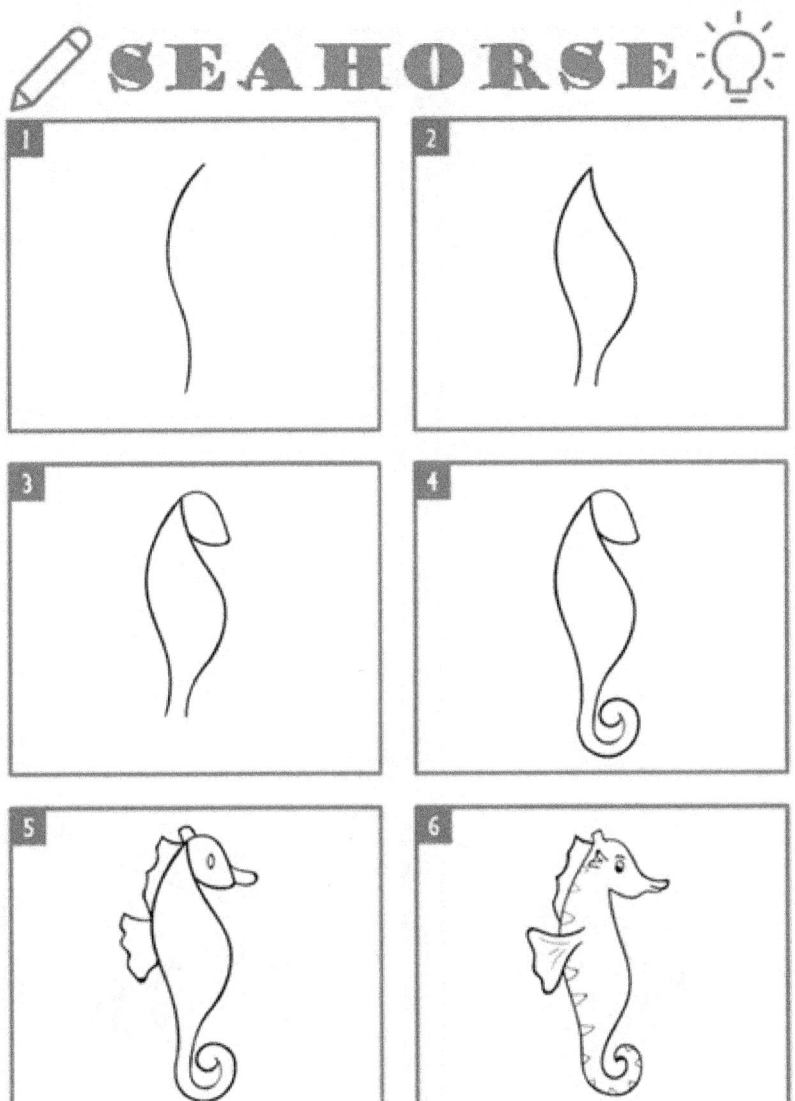

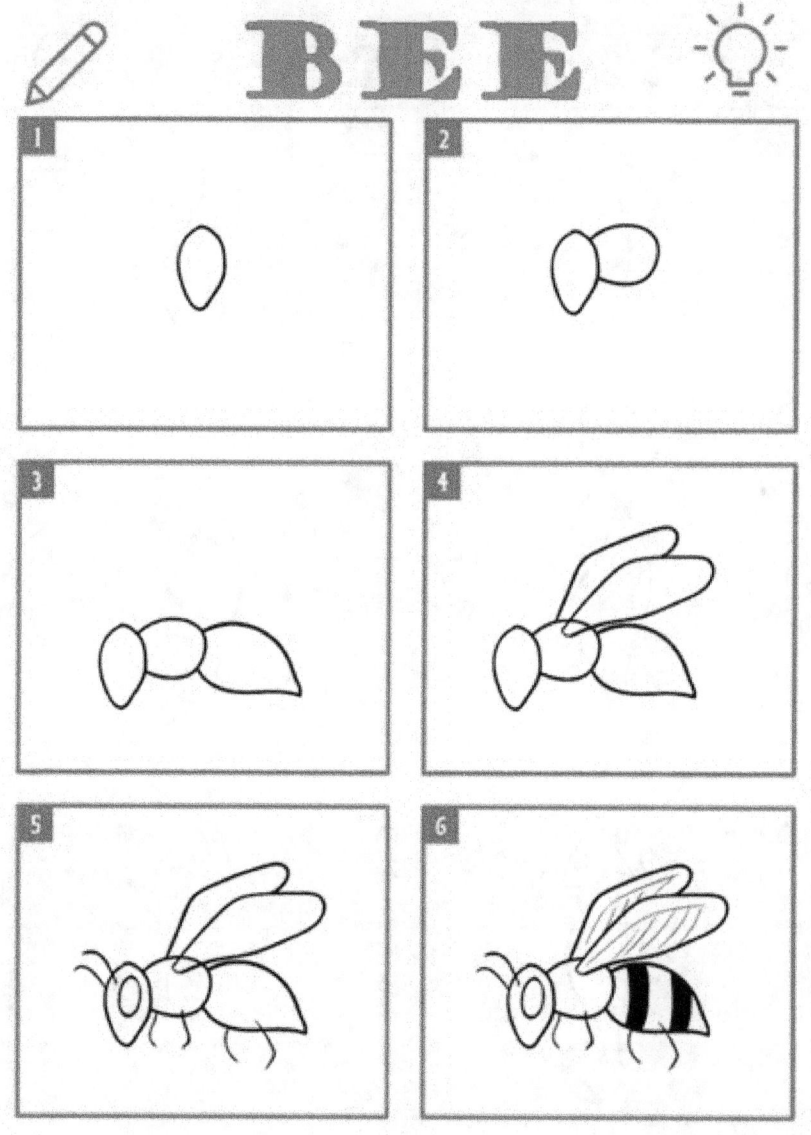

CHICKEN

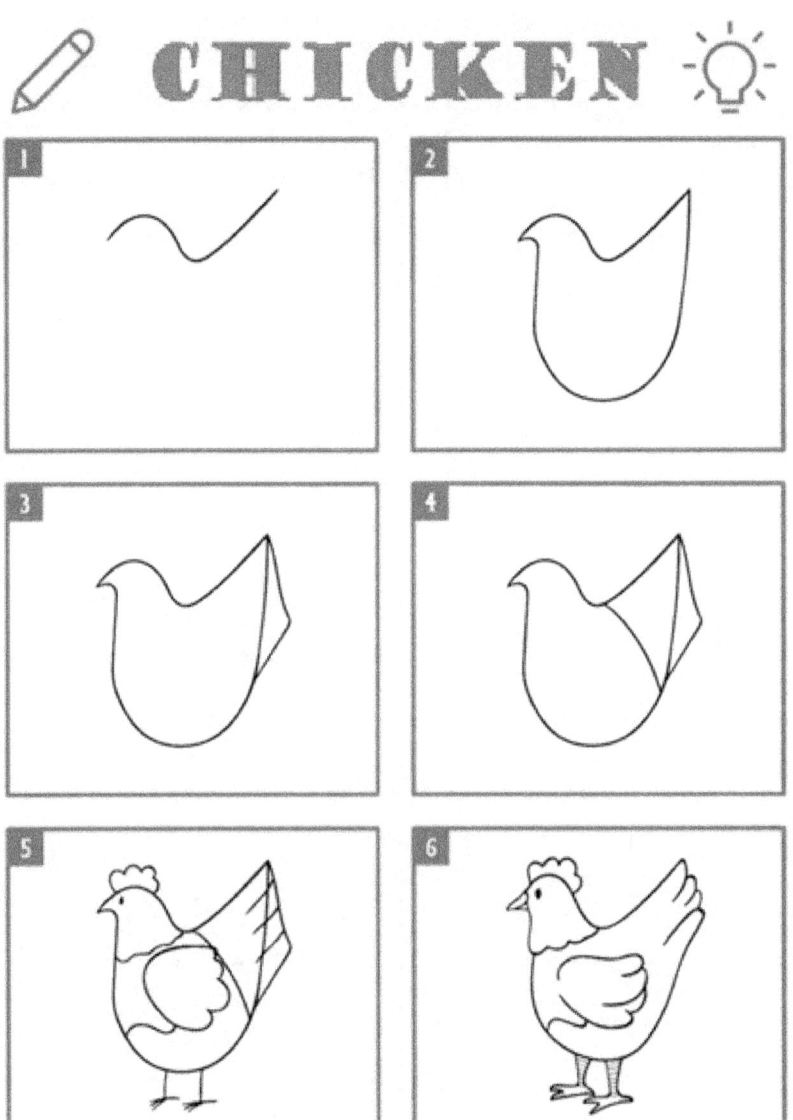

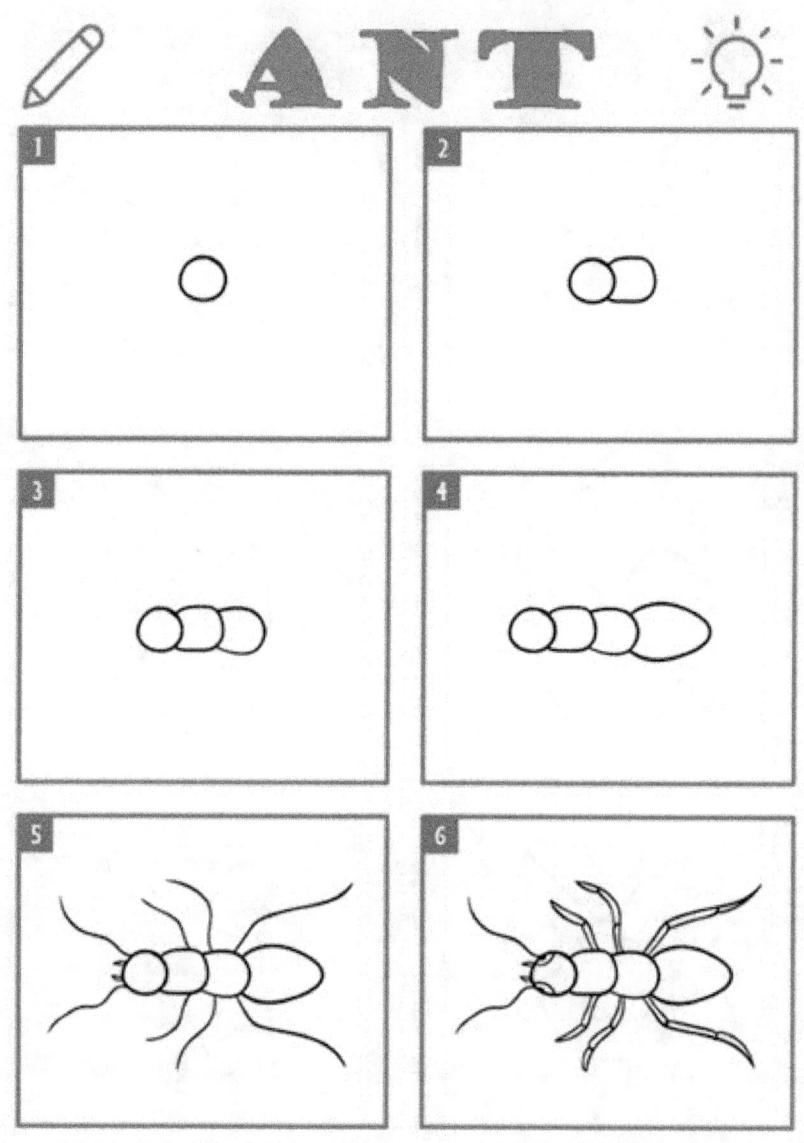

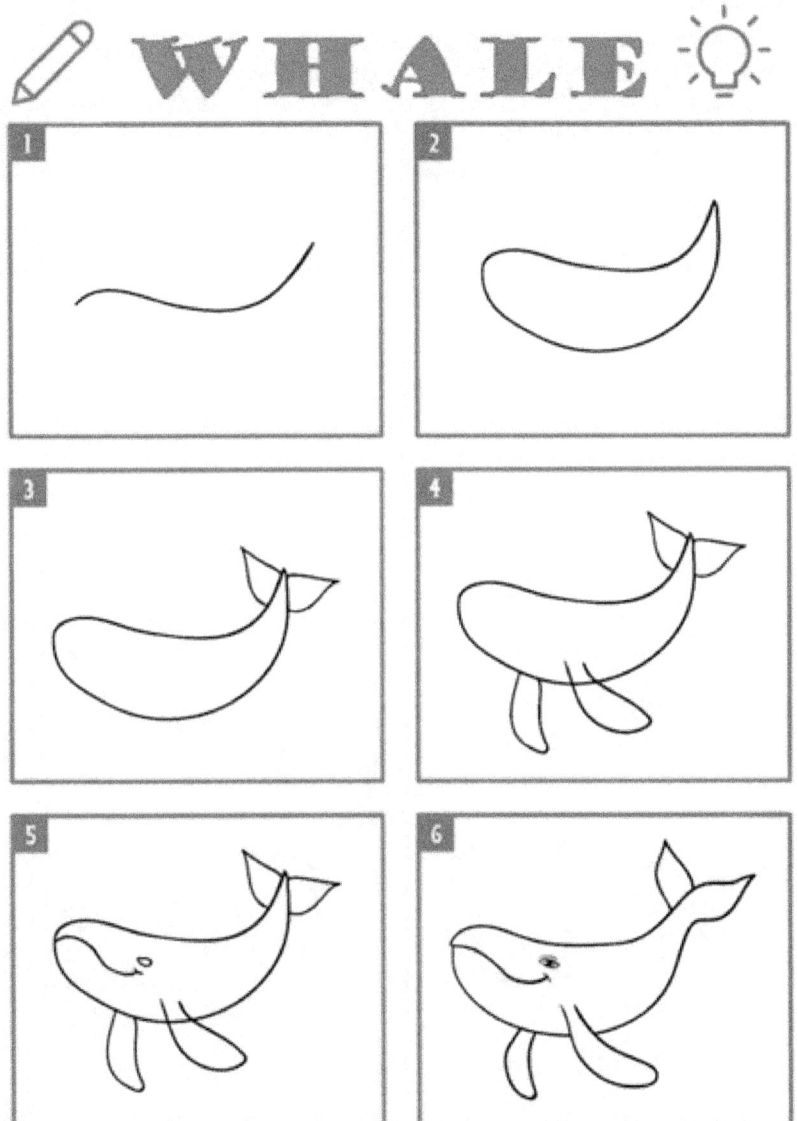

HORSE

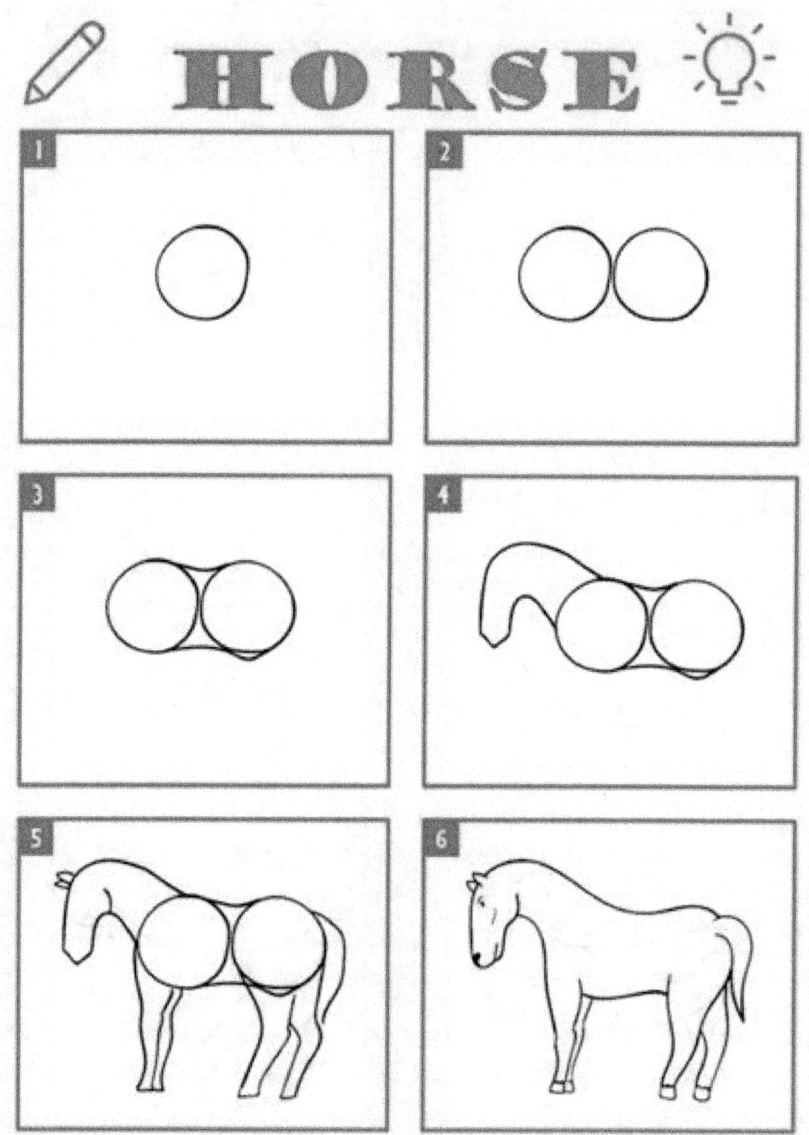

www.ingramcontent.com/pod-product-compliance
Lightning Source LLC
Chambersburg PA
CBHW072311170526
45158CB00003BA/1273